Art Matters!

8 awesome life lessons learned through art

BY

SUNNY DESHPANDE

Copyright © 2019 by Sunny Deshpande

All rights reserved. No part of this book may be used or reproduced by any means, graphic, electronic, or mechanical, including photocopying, recording, taping, or by any information storage retrieval system, without the written permission of the publisher except in the case of brief quotations embodied in critical articles and reviews.

Visit my website at fineartsofsunny.com

to view my artwork and the rest of my published books.

Table of Contents

Chapter 1: The misconceptions of art .. 1

Chapter 2: Problem solving and reasoning .. 5

Chapter 3: Art helps you construct the world 11

Chapter 4: You can't make everyone like you 17

Chapter 5: You start messy and get clear .. 23

Chapter 6: Persevere once you commit ... 32

Chapter 7: Paint over your mistakes .. 39

Chapter 8: Step back and look ... 45

Chapter 9: Doing art is a self-discovery process 56

Chapter 10: Implementing an art form in your life! 64

About The Author ... 71

CHAPTER 1

The Misconceptions of Art

When most people think of being an artist, they think of just the conventional artist who paints and draws. For others, musicians and other sorts of people come to mind when referencing the term "artist". What if I told you though that doctors, detectives, police, nurses, engineers, entrepreneurs, pilots, teachers, and many more professionals alike were all artists? Sounds odd, doesn't it?

There's a misconception in this world that these days, art doesn't matter in real life. "Why do art, what is the point of it?" Many would ask. The truth is, people from all these careers need art to improve such

things as their communication skills, reasoning, visual perception and perspicuity. Doctors need to be able to analyze the patient they are working with. Visual acuity is crucial in a surgeon too. If you are treating an injury, working on an engineering project, investigating a crime scene, or teaching, you are actively seeing, interpreting, and then communicating to your colleague, class, or team, and art can make you better at all of these things. People don't realize it, but they are performing specific artistic skills all the time in their jobs.

I am an artist myself, and believe me when I say I have found ways to connect art to every aspect of life; that is why I am writing this book. I specifically do oil painting and visual art. It has helped me in many aspects of my life and assisted me in realizing my full potential. Your art form can be different though. Art is art, and it is important to realize that it can come in different forms.

And it is not just analysis that art helps you with, but art can solve a wide aspect of problems such as improving focus, teaching you social skills, increasing self-knowledge, making you happier in life, making you grateful, and teaching you other important life skills. Let me show you the exact ways you can use art to improve so many qualities that will increase your daily performance, focus, productivity, and much more! Reading this book will not only leave you with a new and

improved mindset, but it will teach you how to find a personalized action plan for implementing an art form in your life.

Notes

CHAPTER 2

Problem Solving and Reasoning

So how do you get better at problem solving and reasoning through art? Here's the thing, you've probably heard how activities like drawing, acting or playing music, all activate the left side of your brain. The sad part is most people struggle to activate that part of their brain sufficiently! This results in a huge disadvantage in the workplace, at school, or anywhere for that matter. An interesting fact according to a long study at Emory University School of Medicine, showed that our brains are, in fact, originally wired to process art. It is, however, the years of lost space where our world has forgotten the importance of art, which has shut down that part of our brain.

Art Matters! 8 awesome life lessons learned through art

Our brain actually views art as a reward. To get technical, the study revealed (through imaging technology), that the ventral striatum, which is associated with the reward system, was activated strongly when people were viewing a painting rather than a similar photograph. It also stimulated another frontal part of our brain responsible for impulse control and calculating risks. Due to a society that has slowly turned art away from our lives and called it "unimportant", we have gained a disadvantage at these skills our brain normally would give us.

This actually makes it an even more special skill to be able to implement art in your daily life! To reason and solve problems, it takes creative thinking. The brain can interpret technical information, but to make its own decisions and use that information to create something out of it, creativity is required. Take a teacher for example. If you are teaching a class of kids, you need to know the information to begin with, but you also need to come up with an angle of how to teach it.

This goes back to communication, which is part of the whole process. To simplify things, you see something, you perceive it, and you communicate it. This is the basic cycle or process that art helps you tremendously with. Again, somewhere in the middle of this process, you must have high amounts of creativity, and this is the thing that a lot of folks lack.

A study conducted by Adobe revealed that 75% of people believe that they are not living up to their full creative potential. You often come to think why that is, and I don't believe it is because some folks are "born" with creativity. It is sheerly because of the decisions they make in their life that takes creativity away from them. Why will a child draw all over a wall and an adult will live by the rules? Children are in fact born with it, and as they mature, they lose all of it because of the rules society places on them.

While watching a podcast on the businessman Patrick Bet-David, he spoke about how some of the most successful people in the world are childlike. Part of that means they are born to love art and implement it in their lives. The rest of this book will help you regain that quality from when you were a kid.

The whole problem-solving process simply goes like this: You find something that causes you or someone else trouble (a problem), then you find solutions to it, and you take action. That middle part, "find solutions to it", is where the creative process exists. Imagine taking that out! How difficult would it be to solve a problem?

One of the many people who inspire me is Naveen Jain, the business superstar and founder of Infospace and Viome. He is known for thinking big, as he's currently working on mining the moon for

minerals. Someone like Naveen who changes the world does so by solving huge, mega-problems. One must be very creative to solve mega problems like that. Also, take Elon Musk as an example. One day, he wakes up and says, "I'm going to Mars!" The gap between idea and execution requires tremendous amounts of deep thinking and finding solutions to execute a plan.

So you probably got the idea, you need to be creative. That is the key to problem solving. Allow me to talk more about how *exactly* you derive creativity from art. Whenever I get commissions or requests for custom work, clients hand me a photo of what I should paint. It is my job to take that photo and translate it into a beautiful work of art that doesn't just replicate it but adds the "artistic element" to it. The reason I say that each work of art I produce is a journey is because, it demands many hours of constant problem solving and very deep thinking at times.

When you have to turn a photo into a painting, you must see every angle of that photo, in order to bring out the three-dimension, and emotion of that photo. The whole reason people even want art rather than photos is because people connect better with art than they do with a photo. Knowing that someone has made the effort to thoroughly study that photo and produce art with it, makes it just that much more special.

I was once painting a complex cityscape in oils and stumbled upon how I should paint a certain group of windows and have them capture the evening light of the city. Just for a couple of strokes, I had to take a long pause to think. In painting, a couple strokes can make all the difference. One stroke off, and a different emotion or light might be conveyed. Through the process of the whole painting, I come across problems just like this, and must likewise take a few moments of deep thinking.

All in all, art really is one gigantic mental exercise. After an hour of painting, it makes me more productive and effective in solving problems and reasoning than I would be before I took a seat to produce some art.

I also play the violin, another art form, so I can very well connect with musicians. At times when I am trying to figure out intonation or figuring out the quickest way to learn a section, it is a period of deep thinking I have to go through. I see the issue, I think of solutions, and execute action- (the same process I stated earlier). I am making the effort to reason and find ways to fix things. It is simply said, but hard to do.

Going back to painting, the whole picture itself is sometimes like an overwhelming puzzle. From start to finish, there are many problems

along the way to lead up to solving one huge problem, creating a finished painting. By now, you most likely can tell that art is not just fun and games, but requires you to give your brain a workout. The results of "working out your brain" this way, last onto many other things you do throughout the day including your day at work and school.

Notes

CHAPTER 3

Art Helps You Construct The World

When you paint or draw, you are constructing something. You are building something from the ground up. The only difference is that you build in a two-dimensional space. However, your job as an artist somehow makes it visually seem like three dimensional on a two-dimensional surface, assuming you are not doing abstract work with just shapes or such material. I am a realist/impressionist painter. For me, the old masters of the 18th century are a great inspiration. I love realism because I am fascinated with how artists are able to recreate something so accurately.

Sunny Deshpande

When I went to the Louvre in Paris, it blew my mind how accurately the artists were able to capture the life-like effects and feeling of scenes from that era. Over the years of replicating different artistic techniques, I have realized how much more appreciative and understanding I am of the world around me. I strongly believe that artists see the world like nobody else.

A great example references another passion of mine, watches. I am more appreciative than most people for fine, mechanical luxury watches because I am able to decipher what makes up the watch. This way, I have a tremendous appreciation for the craftsmanship, engineering, and artistic beauty that watchmakers spend their hard work and time on to produce.

I feel more grateful for the earth around me and the great wonders of this planet. I am also grateful for the little things. Like when I do a painting of a simple flower pot, I go into the depths of what creates that pot. It is poetry to just describe the process.

I take apart the flower pot in my mind and see it down to the individual elements. I think about the clay that was used to form the pot. I imagine the mud the very clay itself was extracted from. I picture the craftsperson who turn a simple ball of clay into that beautiful pot.

I try my best to see the dimension and thinking of how the mud went from a lump, to a circle, to a pot.

This is a very intuitive deciphering process that you go through on what I call the artist's journey. Like I keep saying, it is a powerful mental exercise and just with that one example of the flower pot, you can imagine how it helps you think better and with more clarity.

Just recall the last time you thought about something as simple as a flower pot like that. Moreover, imagine something grander like an airplane! The same thing as an artist, you go into a whole journey as you "construct" that plane in your mind before you recreate it in your form.

First know what that plane is made of. Go all the way down to the very metal ores beneath the ground. Then somehow come to the conclusion of an entire plane being built at the end. It is really a roller coaster ride to consider what it takes to build that plane when you have this kind of retrospective thought.

Why am I telling you this, you might ask? I just took you inside the journey of an artist! When people see my complex cityscapes and such paintings, they always wonder how I do it. I just showed you the process! You have to decipher what you see down to all the elements that make it up.

To give you some context, if I am creating a tall skyscraper, I sketch not the walls, but the structure onto the canvas. (I don't actually sketch it after years of practice now, but mostly draw this in my head). Then, I go onto the next step of construction. See, I approach the building as if I am really constructing it myself.

When you paint a picture, you must take time to understand the anatomy, the reason for being, the dimensions from all angles, and the light of the object or scene you paint. It is the reason why a lot of artists say that their art allows them to interpret the world around them much better.

Have you ever seen a painting or portrait where the person or animal just seems to be looking right at you? Or what about those paintings in which the eyes just seem to follow you? It is not magic! This life-like effect is created because the artist broke down the eye and the emotion behind it. That is why the artist was able to achieve such a realistic and emotion evoking effect for the viewer.

See, I am forcing my brain to rebuild what I am about to paint. Be it complex buildings or just a blue sky, I reconstruct the world. It is the reason I am amazed whenever I see century old paintings done in such incredible detail, even though they were from the early 1600's.

Art Matters! 8 awesome life lessons learned through art

The artist's mindset is truly special. I really think more people should train themselves to acquire it because it frankly does help you in life.

You are able to construct more from the ground-up. You can start with a vision and manifest it into reality whether it be art or any part of life! An artist named Olafur Eliasson said, "Art helps us identify with one another and expands our notion of we, from the local to the globe". He says that we all have felt being moved by art whether it is a song, painting, performance, poem, or story. When we get moved, it is the experience that gets engraved in our body and memory. We connect to the world. Our understanding of things increases and we gain awareness and knowledge.

So again, to keep things straight forward, you can implement this intellectual ability to understand the world like an artist, by finding and using your form of art, which I will talk about later. Construction is a very important part of an artist's job. It is the bridge from vision to product, and anyone can use that bridge to do this in any career you are in!

Notes

CHAPTER 4

You Can't Make Everyone Like You

If you haven't noticed yet, in life you can't please everyone. You just can't. Artists know this very well and prepare to face the fact. They understand the power of polarity. So, they still maintain their individual style. Some may hate their art, some may love it. The point is, it is better for artists to have that group of people that love their art than have everyone just like their art. Think about that for a moment!

This is yet another powerful lesson from art that we must learn to apply to life. Too many folks spend their time, energy, and effort trying to please everyone. I see it all the time. People switch their opinions

around certain groups of people just to feel comfortable and blend in. With peer pressure, what happens? You go against your beliefs and go along with the beliefs of your friends. Eventually, your individuality dies out.

You have low self-esteem and so, cannot stand up for yourself, or stand up for your beliefs. If you observe and study some of the most powerful leaders in the world, they harness the power of polarity. They use it to their advantage rather than their disadvantage. That is why they become remembered. Just take Martin Luther King for example! He would have gotten nowhere sitting on a couch with his mouth shut, or even speaking, trying to please everyone because he was too shy to voice his actual opinion.

Art is an opinion in itself. When you paint a picture, especially abstract art, you typically voice an opinion. That is where style comes from. The most successful and famed artists in the world have all stuck to their style. Moreover, it has been a unique style that no one else had ever done before.

However, like anything, they were heavily criticized when they first brought out their art, a great example being Picasso. Now look at him, his works are worth millions. The whole world knows about him because he stuck to his style. Had he moved onto something that

pleased more people, he would be just like any other artist. It is funny how all the most brilliant people that walked this planet, were first criticized before they became known.

Albert Einstein was criticized starting in school, then it moved onto later parts of his life. He blocked out the criticism and kept proving to the world through his miraculous inventions one after another. Even Thomas Edison who invented the lightbulb, had a so-called crazy idea. The thing is, people will always criticize new things, and things not seen.

When you bring new ideas to the table, people don't see the ideas at use by everyone. They cannot see what you see. Since those ideas or creations are new, they naturally do not believe them. The same thing happens with art. Until a thousand people recognize a painting, one person might consider it crazy. For me, my style is actually realism mixed with impressionism. It isn't a crazy abstract style, but the power of polarity is why I find ways in my business and in my art to make those subtle variations in my craft to stand widely apart from the rest.

To summarize here, it takes massive amounts of courage to put polarity to work. To gain popularity, it takes uniqueness and individuality. Most importantly, it takes an extremely high level of self-esteem and confidence to convince the world to like your ideas, skills,

work, or anything for that matter. It doesn't even have to be in terms of style. For every painting, comes a lengthy process, and It takes courage to embark on that.

It is like when Stephen Sauvestre had the idea for the Eiffel tower. It was a long operation involving leaps, failures, and feats of engineering as he designed the Eiffel Tower. Now that it's done, we take it for granted. Imagine constructing a whole landscape full of vegetation, flowers, houses, people, and all the rocks that make up the mountains in the background. It sure is a feat and an intimidating one at times. As an artist though, you learn how to take big challenges and divide them up into baby steps. Having the skill of taking your imagination and creating actionable steps is the hard part. All I'll tell you is that it takes years of conditioning your mind and trusting in your capability.

Having faith in yourself applies to many situations. What you should really take away from this chapter, is that you need to increase your self-confidence and believe more in yourself. People tell everybody their self-esteem is high. But then why do so many people fall for the traps of other people's beliefs? Why do so many people lose sight of who they really are? You can't be ignorant of this life skill. It is one of the biggest things I've learned from art and through getting

myself out there more. There is a process through which your thick skin builds up. You also must be willing to throw yourself into some criticism by being sold on what you do and becoming the best at that.

Notes

CHAPTER 5

You Start Messy and Get Clear

This chapter goes quite in line with the last. Perfection is the enemy of all progress. I myself had always told people I am a perfectionist, but I have learned over the years what to and what not to do with the concept of perfectionism. Sometimes it is okay, but for most people, it becomes their enemy in many ways.

To start off. Perfectionism is not even real in life. I mean, take a look around you. It depends on what you consider "perfect", but I'll explain based on most people's view and understanding of considering something perfect. Take a walk in the forest, go to the beach, climb a

mountain, and observe. Do you see a single perfect thing in nature? The ocean's waters are going all different directions, waves crashing against shore left and right. The leaves outside are rough with patterns forming all sorts of shapes. Even with humans, we all come in different forms. People are so diverse, you can't even name a perfect one. Nature and the Earth as a whole is nowhere near perfection, so why in the world do you think anything in life is perfect?

Just do me a favor and ask yourself that question. Perfection does NOT exist. It is like they say, "beauty is in the eye of the beholder". Well, perfection is also something society convinces you of when in truth, perfection is in the eye of its beholder. What you think is perfect, might be downright ugly to someone else. Your perfect, favorite shade of blue might be nasty to your friend. You could like a specific food that your friend hates! You get the point, don't you?

Perfection holds people back like a brick wall many a time. It is actually the root source of the phrase, "Paralysis by overanalysis". In art, paralysis by over-analysis is real, very real. At the end of a painting, anyone can expect a painting to be perfect. Of course, that is the goal, right? You want your end results to please the viewer. However, leading up to that result requires you to get perfection out of your head. You

need to move yourself as far away from it as possible if you are actually looking to achieve results!

Once I was commissioned a very complex palace to paint on a serene lake, I thought it was very doable indeed. The thing was, that painting was huge, and I mean huge. For that much complexity, it would require another whole viewpoint. I would need to really look at things differently from the last painting I'd completed. In other words, it seemed like it needed a new set of eyes, if you know what I mean. As I always do, I first visualized the finished product. I thought of perfect lines and crisp details. I pretty much thought of what I considered a perfect painting.

Then the sad part... I came back to reality and saw the empty canvas I were to work with. Pondering how I should start this, I remembered what I used to tell myself, perfection is the barrier of all progress. "You should just start", I kept telling myself. But I didn't. I left that painting for a week sitting there.

Much later, one day I was eating breakfast and sat staring at the photo the client had sent me and that sad, empty canvas on the floor. I thought, what is the worst that could happen? If I paint something I don't end up liking, I can just continue with the next coat. That's the most forgiving thing about oil painting. You just keep painting layers

upon layers until you are happy with it. It is something my mentor has taught me. Whenever I was scared to start, he would always start me off messy. Messy is good, it gives you a start. It puts some stuff down on the ground for you to work with. Otherwise, you just stay frozen not knowing where to begin.

I decided to just start. I took a clean glass palette. I took just five tubs of fresh paint and squeezed out a few blobs of it. First step, done! I had color on my palette. Now there was no going back, especially when I took my three largest brushes and dipped them in the paint. I started with a technique a lot of artists use. You take a semi-transparent, very dilute solution of a neutral color like brown or grey, and you just cover up the canvas. You can still see the lines underneath if you drew anything because like I said, the paint is dilute and transparent with the thin coats.

I once heard an artist say, "I just hate seeing blank space! I don't care what I use, but the first thing I do is cover up that canvas with whatever color I have on my hands". I have always done that to this day actually. This is very analogous to an important life principle I will address. You need to be courageous and just start sometimes. It doesn't always matter how, but take action! Teach and train yourself to hate seeing the blank space. Fill that blank space up as soon as you can.

Become disgusted when you sit around and see the white canvas. You want to start taking action with whatever goals and ambitions you have in life, or otherwise, the blank canvas just sits on the floor. Then you stare at it for days and months at a time and wonder why it is still like that.

You see, people get intimidated because they don't know where to start and how to start. You need to start messy to develop clear results. I did start messy with that painting, but I made each coat of paint less and less messy. I refined my strokes as I went over them through the period of several coats. I trimmed up bushes and leaves to look more and more life-like. I went over the dull colors to emulate the evening sunset I was painting in the picture. To this day, it is one of the most vibrant, detailed, and in my opinion, the most perfect painting I've done yet.

We often overcomplicate the process because we humans are not made for change. Going from messy to perfect involves change that we don't naturally enjoy. The ability to transition like that, is something that takes practice, but then starts to come more easily. When you are building a business, trying to win first place in that sports tournament, or trying to achieve a big goal, 99% of the time, you start very chaotic and disorganized. You trip over a lot of road bumps along the way to perfection. You look at something big like how Steve Jobs built Apple

or how Henry Ford built the Ford Motor Company, and you think perfection. Take that and rewind time. Think about the time when there were no affordable cars and when there was no Apple. They all had to start from scratch, and it was hard indeed!

Both of these two amazing pioneers in engineering and business went through a mess of problems and obstacles, but they got where they came because they started! Steve Jobs started in a garage with a not-so-nice looking bulky desktop. Now when you walk into those sophisticated Apple stores with impressive glass windows, you think "wow, perfection!"

Even with my first book, this concept *really* stood out. It was the exact example of going from messy to crystal clear. It was probably some of the most disorganized writing I have ever done in my life. It started more like a journal entry or just a little paragraph of an idea I had one day. Then, I started adding on more, and more, and more. It compiled into what seemed like a journal of short stories and lessons. I thought it was awesome until I read it from beginning to end. It was chaos! The thing didn't even make sense! I literally cut out a piece of paper into around twenty small squares and wrote the names of the chapters down on each card. I moved the pieces around like a puzzle

just to organize the chapters into a logical order. I don't even think I had named all of the chapters yet.

I pulled it off though. It took me four weeks to write the book, and twice as long just to edit and make sense of it. I probably drove my editor crazy the first couple times she read it! If I hadn't started that book, even though it was a pathetic mess, I wouldn't have been a published author by age fifteen. Think about that!

Not to mention, it's also better to sometimes just get things out than wait too long. With my paintings, sometimes I just release them. If I don't like them, I might keep them for a couple more weeks to see if I get any more ideas to improve them. If I don't, I pull the trigger and force myself to release them. That is how art works! As long as you are content with it, it doesn't matter what everyone thinks of it. Some people don't like my style. Those who do like it though, love my style. They are the ones who will come and commission from me or buy my paintings.

Again, it goes back to our chapter about polarity and how not everyone can be pleased. Something that is perfect to you, may not be perfect to everyone else. However, you can leverage that to your advantage. Of course, by all means, do not just call something finished when you know it is not, but do not wait too long either. Sometimes,

giving things more time than they need can make you overanalyze, and get you in more trouble and confusion.

So there you go, some huge life connections from one painting! Now that you are done with this chapter, start thinking and ask yourself the following questions. What are some areas of my life where I sometimes become stumped because of overanalysis? Why do I become stumped? Am I a perfectionist? What made me a perfectionist, and does it get in the way of my progress? What are some actionable steps I can take to just start and go from messy to clear using my vision and work?

Notes

CHAPTER 6

Persevere Once You Commit

How many times have you committed to something, and gotten distracted and moved onto the next thing? This is called "shiny object syndrome". I used to have shiny object syndrome and I still occasionally do. I never thought it was a big deal until it caught up to me in life and grew like a snowball rolling down a snowy hill. Almost everyone has or has had shiny object syndrome in their life. I have gotten much better at controlling it now, but every once in a while, I still have symptoms of it. So what is it, and why am I talking about it?

The reason I bring it up in a book that's supposed to be about art, is because it started with art for me. The earliest form of shiny object syndrome was in my art. See, I had the habit of doing paintings halfway and then moving on to the next painting. It is really interesting how much this habit is horrible for art and life combined. I would start a painting knowing this would be the one. I would tell myself this would be a journey, it would be complicated, but it was the perfect subject and composition. I would stay interested through the whole painting and think in a week I would have a masterpiece in front of me. Quite the contrary actually happened in reality though.

A week did pass, and then a couple more weeks, I actually had three or four paintings. Goal achieved, right? But they were three or four paintings one-fourth done. They made the whole room look like a mess, and so I just stashed them in the closet. Some of them are probably still there today.

What went wrong? I would do a painting, tell myself it is the one and then see the next opportunity. The grass is not greener on the other side, it is greener because someone waters it each and every day. I thought my idea was not good enough for the painting, and then decided to paint a different subject instead. In the end, all my paintings were bad; I didn't commit to any one of them.

Good results come to those who commit and put in the work every day, not for 12 hours in one day and never again. Sometimes I do feel like quitting in the middle of a painting because I don't have the patience or excitement to keep going. In your job, in school, or with family, you will constantly be distracted, at some point in time.

The world is full of distractions. Did you know that the average American sees or hears more than four thousand ads a day? You probably don't believe that, do you? Search it up on google. People are constantly trying to sell you another golden opportunity, the one perfect thing. It is your job to sometimes put your foot down on yourself and say "No!"

You need to focus on what you are developing whether it is a business, some type of project, or anything for that matter. There is no "golden" opportunity. Sure, some things might be better than others, but anything has potential if you are willing to put in the work. Stop blaming the thing you are doing, and blame that you are not doing enough to grow the thing to something big!

When you start something, commit to it by being ruthless and being disciplined. Learn to say no to your desire to quit. When people see some of my complex cityscapes, they say "Wow, I could never be that patient to draw each line or window on that!" This is a perfect

example of why art is so beneficial. Your parents probably told you that patience is a virtue, yet you never practiced being patient! Art helps you train your mind for patience as you grow something big and fascinating. In music, it also takes perseverance to write pieces and learn concepts through time.

When Handel wrote the Messiah in three weeks, he did so because he set a goal and persevered. He did not say, "maybe this piece is not good enough!" "Maybe I should start something else". No! You finish something when you start it. To the people who have climbed to the peak of Mount Everest, they did not come to the mid-height of the mountain and say, "how about we just climb that other mountain over there". "That's probably better for us!" It can take months to see results and sometimes even years. Tony Robbins said, "We underestimate what we can do in ten years, and overestimate what we can accomplish in one year."

After I started committing to painting, I actually started producing more of them. I remember when I did two paintings in one day! I promised myself that if I wanted to start another painting, I would finish the one I was working on.

Luckily, there is actually a way to identify whether you will get distracted or not on something you start. It helps you know in advance

if you genuinely hold interest in the thing you are about to pursue or not. The first step is to ask yourself if you are inspired or motivated to do something, or if you are just kind of interested or kind of driven. Let me explain the difference between being inspired and motivated.

Steve Jobs was inspired when he built Apple, not motivated. Inspired is long lasting. It never dies out, it never suffers from burnout, it never grows bored, and never loses energy. When you watch some motivational speaker just preach and not teach, you get a burst of energy, but it is gone the next day. Beware of people like that. Beware of "fake inspiration" where you are just excited and inspired for a day. A true inspiration to do something must last for years if not decades.

For me, just the passion of doing art, is something that has allowed me to actually monetize it at such a young age and without going to art school. Since going to museums and reading about great artists like Monet, I have been inspired for years at how artists are able to move people through their work and how they are able to create such unbelievable masterpieces that stand the test of time. This is true excitement. It is not a burst of energy, but more so consistent energy that fuels you for a lifetime.

For many years I taught myself painting, that's how much I wanted to learn oil painting. I actually have been an artist since I was

probably three years old. I just don't tell that to most people because they tend to want to know the professional side of things. Nevertheless, I have been doing it for a long time. I have passed the test of being inspired and not just motivated. Now art has led me to so much more in life, including writing this very book.

Furthermore, when you are inspired, you commit and it is easier not to give up during hard times! Inspiration of a particular subject in art keeps that painting going. It prevents all kinds of things including shiny object syndrome. The reason I was experiencing it before with my paintings was that I was just painting for the sake of painting. I had no reason behind the subject I was painting. There was neither inspiration nor motivation behind the subjects. I picked a photo I *kind of* liked and started. No wonder I didn't finish!

Be intentional in your actions. Simon Sinek's book, "Start with why?", talks all about finding your reason behind doing things. Every time I start a painting, I now ask why I am doing it and what I want out of it. With this book, I also started with why I was writing it. Then, I was easily able to create a table of contents, name the chapters, and write. If you are not intentional in your actions, growth, learning, or whatever it may be, it will not happen. It is the way to persevere as some might say it. But you might not even need persevering because the process will come so naturally when you are inspired to do it!

Notes

CHAPTER 7

Paint Over Your Mistakes

Painting over your mistakes, is what I love about oil painting. It is why it is my absolute favorite medium when it comes to visual arts. I have done watercolor, I have done drawing with graphite, charcoal, I've done acrylic, and pretty much all you can name! The reason oil paints are the best to work with, in my opinion, is because you can paint over your coats no matter how many times you mess up. Even if you see a mistake a day later, the paint is still wet. It can take 3 days to more than a week for oil paint to dry. It is frankly the most forgiving medium out there.

I used to avoid oil paints because I thought they were messy. Really, I just didn't have the right materials. Once I learned the right techniques and fundamentals of oil painting, I fell in love with the medium. It pretty much has everything you could ask for. It withstands the test of time, it yields vibrant colors, and is very fun to work with.

You are going to mess up the first time you paint. Moreover, you are going to mess up the first time you do anything in life. Whether it is a new hobby, learning a skill set, or entering a new job, you're gonna make mistakes the first time.

Something that art taught me was to not overanalyze the mistakes and instead focus on the future, which in this case would be the next coat of paint. More often than not, if you do a good enough job on your following coats, your past mistakes can be covered up. Also, you can never go over something with too many coats. You should not be afraid of making too many mistakes in life. Just think that there is an unlimited amount of paint left for you to go onto the next coat.

A common thing some people do is assign themselves a limit for how many mistakes they can make. While you should try not to make mistakes, you don't get much out of focusing on the past ones either. Again, you have an unlimited amount of coats you can put on your canvas!

Everyone's canvas starts blank, but those who are willing to take a risk and make mistakes are the ones who move forward. Those who have made, recovered from, and learned from their mistakes, have a more vibrant and finished canvas. Full of more coats, their canvas shows their experience and knowledge over time.

My progression in painting has shown just that. I have literally painted repeatedly over my mistakes until now I produce work in just a few hours that blows people's minds. I show them something from two years ago when I did art as more of a hobby, and people don't think that it's my painting.

The truth is, I have painted hundreds and hundreds of coats in my career, and people only tend to pay attention to the top coat. People will always know you for your top coat in life, never the ones below. I mean in painting, you physically can't see the ones below! In life, it works out quite the same.

That is why you can never add too many coats, because people will always see the top. When you work on self-improvement, for example, people pay attention to who you are now, not who you used to be. It doesn't matter if you were say, a better leader a couple of years ago. No one cares! They care about who you are now. It is pretty

common sense. If you are a bad leader now, they don't care even if you used to be a good one. This is the same thing in art.

I have to always keep my current style and work my best and up-to-date because I know people will judge me for the top coat, about my work now. I, therefore, make sure to update my portfolio once in a while. Over the years, I have actually taken out some of my old paintings from my portfolio, because I want to show people who I am now, not who I was a month or a year ago. (I do have a few old ones just for the sake of people's curiosity though).

Another related concept here is that in art, you go with the flow. For most people, their life also involves some part of going with the flow. Very few can tell you their future ten, twenty, thirty, or forty years from now. It usually takes experimenting and trying new things for people to decide what they want to do with their life. When I start a creative painting of my own, sometimes, I don't know what it will look like.

It is one-hundred percent true that you should have a vision, but usually, your vision can get influenced by sparks of new thoughts and ideas as you rise towards your goal or end result. In the process, you have to allow room for changes or mistakes to naturally happen. As you

paint over them, you are going with the flow. If you get one result and it doesn't work, you go onto the next step.

The reason life tends to be like a journey after you look back, is because you were figuring it out as you went. Many people end up with a completely different future than they planned they would have. When I was younger, people told me for years that I might change minds of what I wanted to do when I grew up. I doubted them saying that would *never* happen to me in a million years. I was completely set on what I wanted to do. I wanted to be an airplane pilot from age three to thirteen, since I have always been fascinated with aviation. My passion and excitement for entrepreneurship and business though took over, and I've completely changed paths on what I want to do for the rest of my future, (even though I'll probably get my recreational license just for fun).

Some things are just unpredictable and that's the way they are. You need to adapt quickly and get over the minor things as fast as you can, so you can make room to give your energy to activities that improve you and take you where you want to be.

Notes

CHAPTER 8

Step Back and Look

Art has been full of ups and downs for me. There are days when I sit in front of the canvas and dread the painting process for hours. Then, there are days that I sit in front and get a whole painting done in an hour. It really varies. For some people, they sit down and are able to do the work consistently whether they are tired, whether they are energetic, and whether they have ideas or not.

I honestly thought I would be one of those people because of my talent and passion for art, but as time went by, I have found it to be quite the contrary. For me, that's just how it is. Though I may know a

thing or two about art, there are days when my talent just won't come out. Every time that happens, I do two things; I put some paint out onto the palette and try dipping my brushes into it.

I spend some time with that and if it doesn't work, I wrap it up. It's no big deal, because I know that in a day or two, it will come to me. Sometimes, I even take a month break from a painting, and many times a month is needed, though it sounds unnecessary and ridiculous. I always tell people, the painting process is not what takes time for an artist to paint. If that were true, I would be doing one highly detailed painting a day and I would be turning out 365 paintings a year. Of course, that doesn't happen, especially with my realist style. It is the stuff in between, I tell customers, that an artist takes time on. This includes the drying periods, thinking time, rendering time, and much more.

So that is the first thing I do, I take breaks if it does not work out. The second and most important thing I do is actually what the title of this chapter is. It is one of the most important, yet simple things I have learned in my art career. It is something that I have reapplied to the problems I encounter which are unrelated to art. Anywhere in life, if I feel stuck, I find a way to use this technique.

Art Matters! 8 awesome life lessons learned through art

My art teacher told me one day when I was practicing in his studio with him, "Sunny, why are you using the same motion on this one tree?" Confused, I didn't know what he was asking. "What motion", I questioned. "Your hand, I see it moving in the same direction again and again; up and down, up and down", he replied. It was then that I realized I wasn't even paying attention to the tree, but just the leaves and painting them green. He told me to step back a few steps.

I looked at the same tree and it looked wrong. I sat back in my seat. It looked normal. Even though the repetitive pattern of identical and awkwardly unnatural leaves looked normal from there, they were noticeable to me only from a few feet back. Though they were disproportionate and wrong, I was led to believe they were fine because I was sitting there staring at them so long that I convinced myself to believe that everything was going well.

Think about what just happened there because it is a powerful lesson. You have probably heard of artists stepping back to look at their work once it is done, but when is the last time you did that with something completely unrelated to art. People get stressed and don't solve problems because they stare at them one way.

As a more experienced artist now, I have six different ways I look at my work as I paint. Yes, you heard me, six! I also have engraved in

my memory, to change viewing positions at the end of specific timed intervals. This keeps me from wasting time on one part too much and helps me to quickly spot errors.

To prove that this works with much more than just art, think of the last time you looked at an optical illusion. You might have played with those challenges when you were younger where you have to spot a hidden figure amongst a bunch of shapes, or something related to that. Some people can figure this out in a jiffy, but for the majority of folks, it's nerve-wracking! Well, guess what, life is an optical illusion too for many people, even though you may not think so at first.

Your future goals are an illusion at first. For younger people in high school, their future career is something that may be an illusion. Even short term problems can be illusions. The point is, real life is filled with optical illusions. That's what makes life fun though, because you gotta figure it out. I have had a number of times I've needed to step back, forward, left, right, sideways, horizontal, you name it, in order to figure out a sense of direction in things I just felt lost in. To see differently is hard because you force your eyes to send you information a different way than they naturally do.

At times, this can seem impossible, which is why some people just can't help but get tricked by those optical illusion tricks back in our

little example. As an artist, I have been training my eyes for years and years of learning and application. Looking at the broad picture more, or taking a step back is just one of the things I do, but really changing your perspective can mean a lot of things. For example, when I talked about my first technique in which I take a break from a painting and come back to it, that is an example of changing your perception. You let your eyes forget about how they normally see something, and you come back to your problem or in this case, painting, and you let them process information a bit differently.

You can't force your eyes to send the wrong information to your brain, but you can give them a break so they can get refreshed and send new information to your brain even though you're still looking at the same thing.

Just like the filmmaking industry, several focal lengths are involved in every aspect of your life. Your actual life is made up of close up shots. In other words, your eyes are focused on what you need to get done every 10-15 minutes. Your attention is on your to-do list for one day at a time. I mean, you never go through your day focusing on "life goals", 24/7 do you? Most people don't!

Another example of this is when you write a book like I am doing right now! When I am writing, I am thinking of every next sentence,

not the whole book! Since I have broken down my ideas into actionable steps and sentences, I am concentrating on the actual writing, instead of the idea of the entire book. That is a good thing because the details and short-term steps are what allow me to accomplish my goals.

Moving on to the central point though, when you step back, you prevent yourself from getting bogged down in the details. The reason people get bogged down in the details is because they feel discouraged as a result of losing sight of where they're going. It is easy to find yourself lost in a mass of actions. If you work like your life is a never-ending treadmill, you naturally become focused on the one action you are doing again and again. On the other hand, if you see different perspectives of your task, your life becomes a hike through the mountains, rather than a treadmill. Stepping back mentally is almost the same as physically backing up to view a painting.

Also, just to be clear, when I say take a mental step back, I don't mean a mental break. I am talking about trying things a new way, switching your train of thought, taking the road less taken, and seeing things differently than you have. As you are producing and making progress on your projects or goals, pretend like you are someone else who is seeing your work for the first time. Try to switch to a "3rd person" point of view and see the results from a viewer's eye.

Art Matters! 8 awesome life lessons learned through art

We all have been told that focusing is one of the keys to fast success. Well, "unfocusing", or stepping back to look at the whole piece actually helps with having laser focus. Imagine you have a goal to learn how to play the guitar, and you are a busy working parent. Learning the guitar is an awesome goal to have, but with so many tasks coming your way, it is easy to subvert from your goal. When you look at every single task that is on your to-do list, you lose sight of your goal to learn the guitar. If you take a step back every week or so, you can check if you're on track, so you do not go down the wrong path.

From earlier in the book, something else that can also be prevented by switching viewpoints is shiny object syndrome. You gain a larger sight of objectives and you become intentional in the important things. It helps you decide whether an opportunity is actually worth pursuing or if you are just getting back into the trap of shiny object syndrome.

So, I am going to give you six ideas other than art that you can apply in your life to actually step back as I do with oil painting. These are things I've used both in business and each painting I do; they have helped me develop clarity of where I am going. Idea #1 is to write. Yes, I see the coincidence in that! Really, writing is the best way to reflect on your progress and thinking from a third person point of view. It gives you a way to clear the noise in your brain and get it down on

paper. I always tell people that the reason I write books is for myself, and it is because they are self-improvement exercises for me.

Secondly, reserve thinking time. Many successful people keep thinking time in their schedule. It gives a chance for your brain to settle down so that ideas can come to you rather than you chasing them. I was watching Shark Tank once and saw an entrepreneur tell the sharks that they got their idea in the shower. Shower time is thinking time! Another example: I was sitting at a business conference listening to businesswoman Sara Blakely speak about how she uses driving time as her thinking time. I could relate to this. Whenever I am in a car, that's when I allow my brain to wander off and allow room for idea generation.

Many people have great chances for thinking time but are blind to these chances. They complain they don't have time to waste just to think about stuff. In reality, you have several chances throughout the day where you could utilize good thinking.

The third method of stepping back is to meditate. The health benefits of meditating are incredible, and it is a proven science. Many of the world's most successful people also meditate. It gives you energy, focus, and quality thinking. Importantly though, it lets you come back

to reality with a refreshed sight. You clean all the distractions that your brain may have witnessed throughout the day and been polluted with.

When you rinse your mind of these hindrances, you retain the clear sight and thinking you had from square one. According to inc.com, some of the uber-successful folks that make meditation a daily part of their life include Jeff Weiner, Arianna Huffington, Jerry Seinfeld, Ray Dalio, Bob Stiller, Russell Simmons, Andrew Chert, Robert Shapiro, Oprah Winfrey, Tai Lopez, Naveen Jain, and the list goes on!

The fourth point is to watch a movie! Yes, a movie! Watching long films can inspire you and change your state of mind. Of course, watch meaningful movies that are worth your time, and they will actually help boost your performance. The reason good films are effective is because they take you into another world on TV that you would otherwise not witness. This again clears your mind of the current problems or issues you are dealing with.

The fifth method is to go to a conference. I recently came back from Grant Cardone's 10x growth conference. The speakers were amazing, and after that 3-day weekend, my performance improved. I was filled with energy and inspiration. I felt like all the useless thoughts were completely drained from my mind and refilled with extremely

useful knowledge and new visions of where I am going. The reason I say go to the actual conference, and not just watch a recording, is because the environment you put yourself in has great effects on your thinking. The people around you influence your vision and thoughts.

My last idea for you is to get a mentor or life coach. Mentors and coaches help if you struggle to get perspective by yourself. Coaches can help you in seeing that other perspective that you have a hard time seeing. They see a big picture for you when you are thinking small. If you already see the big picture but don't know where to start, coaches help you see baby steps to get to your goal. It will help you make faster progress and move along while avoiding a lot of mistakes.

Think about and note which one of these steps stood out to you the most. Try implementing them creatively in your life. Keep them in the back of your mind so that whenever you are lost or have trouble being productive, you can easily put them to use right away!

Notes

CHAPTER 9

Doing Art Is A Self-Discovery Process

The more I've painted, the more I've gotten to know myself. The more I've worked on intricate details, the more I've gained awareness of who I am. Art is a long self-discovery process in that you use art as a tool to process your past, present, and future. The journey you go on through art embraces the larger, life journey you've been on that makes you who you are today.

Art allows one to explore their abilities, talents, strengths, weaknesses, and interests. Just think, the reason no two paintings are ever the same, is because the individual is so different from another. It

is what makes art so valuable to people and so precious in the hands of someone who truly appreciates it.

If you notice, any luxury item in the world usually involves art. Art raises value because it has the human touch. Otherwise, most things nowadays are manufactured rapidly in the hundreds each day.

Art makes things special. People all have different attractions to different types of art. Some people like watches, some like fine automobiles, some like collecting sculptures, paintings, etc. Everyone has their favorite form of art!

Art is unique because it is an expression of the artist who formed it. In the painting world, people have a whole array of opinions when it comes to their taste of paintings. Some visual artists do abstract work, some do hyperrealism, some artists do impressionism, and some have their own invented technique. Whatever their style is, it usually reflects their personality.

From the work of a good artist, there are times you can just feel the emotion coming out of a painting. Whatever the artist intended to express through the work, is evident through the type of strokes, intensity of color, and blends of paint.

For painters, as you develop your skill, your style changes. I have been painting for years now and have come to settle on my style like I discussed earlier in the book. As I said, I have experimented, half-completed paintings, tried different mediums and even took year-long breaks in painting. This whole process has been a self-discovery process for me though. As an artist, I would say it was well worthwhile.

Now, I have my own unique style that provides self-recognition. Once I had left one of my paintings to dry in a gallery, the owner came the next day and asked if that was my painting. It still was not finished and she recognized it as mine. This is when you know you have developed a style.

Through art, I have found out what I like and don't like. I have also narrowed down on the subjects I like to paint and don't like to paint. For example, I don't do portraits. I have drawn them in the past, but landscapes, architecture, nature, and still life are the subjects I Like. Now I know.

Finding my style has allowed me to take art much more seriously. Before I would do it on and off as a hobby. Now that I know what to do, I am able to actually commit to developing my skill. It is the same thing with your life's career. Once you narrow down on what you want it to be, you are able to commit all the way and not do things half-way.

That is the real purpose of finding yourself. Some people call it your "life purpose", but in my opinion, it is just what you want to use your time *most wisely* on, in life. It is also what you want to get the most fulfillment and happiness out of. It is crucial to discover yourself to make the most out of your time on this planet. Socrates said twenty-five centuries ago, "Know thyself". Art helps speed up that process because it is something that brings out your strengths and passions so that you are fully aware of them. You want to be able to use your time on meaningful things!

The questions you ask yourself through in-depth and intentional art, are "who am I?", "why am I here?", and so forth. Release your self-consciousness into a form of art whether it be music, literature, painting, etc. Religions and ancient scriptures all have sacred forms of art because the concepts and meaning they are trying to pass on just cannot be conveyed in words or speech alone.

In the modern world, art has been called "therapeutic". You may have seen or heard of products like "adult coloring books" on shelves. Well, that's not just because it is a new fad. Art therapy has actually been encouraged to be used by cancer patients! It helps cancer patients come to terms with their current situation and conditions by expressing their mental state. Self-expression is always a powerful way to clear and compose your mind in the case of stress and chaos.

Too many times, we are going outward. While you want to go further and further outward, you must go inward to go outward. Let me repeat that, go inward to go outward. It is comparable to the saying that history tends to repeat itself. If you study the past, it helps gain clarity of your future. History repeating itself may be arguable, but the fact that you must go inward to go outward is not! That had been proven in all the great leaders in the world from the beginning of time.

They knew themselves and their mission enough to be crystal clear on their goal. Whether those leaders were bad or good, they had a goal clear enough to never run out of energy and focus in order to achieve it. It is easy to manifest a vision when the vision is right. Too many people follow the wrong vision, or they create the wrong vision. For example, if someone asks me to create abstract art, I wouldn't be able to do it! Now being an experienced artist, maybe I could "fake it", but you would be able to tell it is not genuine art.

My style right now is recognizable and unique to me because I have had the patience to discover myself in art. As time goes on, my style may vary based on the outside matters that influence my personality. Nevertheless, my art will always be a reflection of myself. Now I am applying this lesson to larger ambitions and goals in life. I

may have found myself in art, but now, it is time for me to keep making the effort to find myself in other aspects of life.

Going back to shiny object syndrome, another reason people jump from opportunity to opportunity is because they have very low self-awareness. They think that what worked for someone else will always work for them. They are not confident in themselves, so they put their confidence in other individuals. Once you discover yourself through something like art, your confidence goes up to keep repeating that style. And when you believe in your style like that, people will naturally be in demand for your artwork.

The funny thing is, whatever mood I am in when I am painting actually reflects how my paintings and strokes turn out! Sometimes, if I am frustrated or stressed and I sit down to paint, my paintings actually turn out bad! I never expect them to, but they do. Art is very credible in that respect. You can never really fake it. I can't take another artist's style and copy it because I am not that artist. It is as simple as that. This is why I encourage you to take some time throughout the day to do something artistic. When you do a little of it every day, you'll see big progress.

It will allow you to have introspection time which will boost your performance in other work throughout your day. Things that seem

irrational, will seem rational. Problems that seem unsolvable, will seem solvable. Once you discover yourself, you will unlock infinite potential. So, before you move on to the next chapter, write down five ways art helps you gain self-awareness, and list five ways self-discovery is critical to your life.

Notes

CHAPTER 10

Implementing an Art Form in Your Life!

You've read all about art and its importance and reasons for being. Now, I am going to help you specifically, to implement a form of art in your own life. This last chapter will really open up your eyes to the infinite ways to utilize art in a broader perspective.

The first thing that must be understood is that art comes in many shapes and forms. You may not see art in everything, but in most things, there is always a form of art. Art can creatively be woven into a subject, career, or lifestyle. Many people ask me how I am able to have both the right and left brain as a strength. I love technical stuff as well

as artistic subjects. The truth of it is that most people are perfectly capable of being like me even if they are too technically minded. The only thing they must do is practice some form of art routinely. That trains your brain to work while using both sides of itself more.

When you shut down one side, the imbalance happens. You become less creative in your technical work and can't solve problems as well as you used to. You are also less able to be calm and focused as your performance decreases. This is why you should train your brain to have both the artistic side and the technical side.

One of my friends is an engineer and works in a technical field, yet he has his own band and plays the guitar routinely. That is his form of art. He has a passion for music and it activates his creative side. He is able to go into another world when he wishes to. Since he does it so routinely, he maintains his mind's balance!

Music is an example of an art form. I have been playing violin for years and it has had similar effects as painting in my experience. The one difference is that music involves math and art at the same time. It is one of the best types of art to activate both sides of the brain.

My violin teacher was helping me with a measure once, and we took a break between practice. She showed me how she was trying to teach younger kids who found it boring to read traditional notes on a

page. And so, my teacher would actually use different shapes and colors to indicate notes and teach her younger kids. It was entertaining for them and they learned quickly. "This is my art form, Sunny", she told me. For my teacher, her ability to teach the kids in a creative way like that was actually a way for her to habitually practice art throughout her day!

The amount of ways you can make room for art in your life are unbelievable. The possibilities are simply endless. You see, an art form does not have to mean traditional forms of art like singing or painting. It can be embedded in ordinary careers and objects. Steve Jobs was an artist! His sleek IPhone and IPod were the first of its kind. No one had ever seen such a sophisticated and simple device ever before.

Steve said that he wanted the part of the computer not seen, to be just as beautiful as the part visible. That sure holds true today! Just look at the simplicity and beauty of an IMac desktop computer today! It looks great on all sides. Now when you walk into a store, you can immediately tell which devices are the Apple ones and which are the other brands.

Just ask yourself, what really separates the Apple product from the rest? The fact is that Steve Jobs created a work of art with a story, while other brands kept producing devices that just "did the job". Again, art

boosts value in things, because most people or companies don't involve art in their life or what they create. Even the computer engineer can be an artist. He/she just needs to find a way to do it.

One of my favorite quotes by Steve Jobs is, "Design is not just what it looks like or feels like. Design is how it works." Apple products have art in how they function too! For instance, the simplicity of using the IPhone is a unique art. The literal definition of art is the expression or application of human creative skill and imagination, typically in a visual form such as painting or sculpture, producing works to be appreciated primarily for their beauty or emotional power. The line that stands out here is, "Expression or application of human creative skill and imagination". Take a moment before you keep reading and just think of the infinite abilities you can have with art. Did you think of art with that definition in your head before? In one line, what would you say art is?

To incorporate art in your life, it has to be personal. Each individual is so different that it is hard to just say what will work for that specific person. I could tell you hundreds of ideas about ways to do art, but you can just google that! And if I did want to just tell you, I could just copy and paste a list of them! I want to give you more meaningful advice, more on how to find the right method for you! That's what I have been trying to do throughout this chapter!

The whole idea is, you want to find a way to express anything you normally do in different ways. What I mean is just what the definition of art I gave you said. Find a vehicle that allows you to express whatever it may be in a creative and imaginative manner. It can involve subjects in the past, present or future. For example, when I was bored, I just sat down one day and drew a picture of a Rolls Royce. It is my dream car. I was expressing my hope of owning it in the future through art.

You can also reflect on your past or express feelings that commemorate special times in the past. Something from your childhood, maybe, that you want to revitalize in your mind is an example. Maybe acting out that event from the past, will help refresh your fond memory of it. As you can probably tell, there is a lot of out-of-the-box thinking going on here. Remember though, be creative, but don't overcomplicate it!

Also, to clarify the term "expressing" in terms of art, I mean to express your emotions, your dreams, your goals, your feelings, your ambitions, your sorrows, your happiness, and so on and so forth. And that is it! It is not really that hard. If you haven't noticed, this is the last chapter of the book, so we are at the point where we'll wrap it up now. Hopefully, this book has changed your mindset. I am all about mindset and think it is extremely important to any actions you take.

Art Matters! 8 awesome life lessons learned through art

My goal is to improve your life in some way, whether that be big or small. Leave a review and let me personally know how you liked this book! And, if you would like to see my own artwork, visit fineartsofsunny.com! Good luck and thanks for reading!

Notes

About the Author

Sunny Deshpande is a self taught impressionist/realist artist who has been passionate about the subject and has been doing it for more than a decade so far. He decided to turn this hobby into a business and has now done commissions and sold numerous paintings for many happy clients. Following this, he's also written and published the book *Entrepreneurship Changed the Way I Think,* in which he shares many of the lessons learned behind monetizing his hobby at a young age. Art has been a profound and influential matter in his life as he's taken away a lot of significant, larger life lessons and connections from doing it, which he shares right here in this book!

www.ingramcontent.com/pod-product-compliance
Lightning Source LLC
Chambersburg PA
CBHW070815220526
45466CB00002B/670
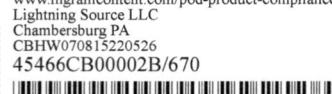